GW00372134

A Journey Within

Charlotte Birnbaum

A
Cooking
Journey
with
Within
Offal

Illustrated by
Christa Näher

Translated by
Erika Banks

Verlag der Buchhandlung
Walther König

Cooking with offal is an almost-forgotten art. Yet there is nothing more delectable, and a great adventure awaits those who are open to discovering this virtually unknown territory. My own journey through this 'inner-realm' has been more than worthwhile. What I am presenting here is not in-depth cultural history, but rather simply a collection of recipes for easy to prepare yet extraordinarily tasty dishes. I have tested them on my family as well as discerning guests from all over the world. My motivation was my own curiosity and also my interest in culinary variety; something which is in danger of disappearing of late. More than anything though, it was the fact that, for me, nothing is as delicious as a slice of calves' liver fried in good olive oil!

Offal is provocative. Why? Might it have something to do with the word offal itself? What is the offal truth? The term is rather unfortunate. It has nothing to do with being awful, rather it is derived from those parts that 'fall off' or are rejected when a carcass is dressed.

Has it got something to do with the horrid fried liver that we were forced to eat when we were children? Is it because offal is internal organs and not muscle? Is it the consistency or the blood or the fact that innards seem to be unseen, unknown and uncanny?

One reason is surely a lack of knowledge. These parts of an animal are difficult to obtain nowadays; one rarely sees them. Most small butcher shops have been taken over

by bigger ones and the processing of offal is clearly no longer profitable. The innards are often simply disposed of – or may be lucky enough to end up in a sausage. The legendary Swedish chef, Tore Wretman, writes: "One can easily mix everything into a sausage that would otherwise demand work, effort, imagination and knowledge in order to make it delicious." Anyone can tell you what a sausage looks like, but what about a calves' kidney? The general opinion regarding offal varies greatly from country to country. In France there are special shops, *Triperien*, veritably bursting with delicious sausages and pâtés. Of course a large selection of fresh offal is on offer, the *morceaux de goût*: heart, kidney, sweetbreads, brain and maybe even spleen and animelles (an elegant euphemism for a certain pair of masculine organs). The word 'Trip' also means 'interest payment'; it is, so to say, a bonus – those who helped with the slaughtering of an animal were allowed to have the offal, which would otherwise not keep.

From Marcus Gavius Apicius, the author of *On the Subject of Cooking* (300 AD) to Charles Emil Hagdahl, the most influential Scandinavian gastronome, no serious cookbook author has left out recipes with stomach, calves' feet, pig's ears and cockscomb. It has always been natural to use the entire animal.

What is eaten and where, is a fascinating topic. It is well known that offal is highly regarded in Chinese cuisine and is especially prepared for celebratory occasions. This

culture regards internal organs as valuable and exclusive. Indeed, the internal organs do only constitute a small part of the animal — maybe this makes them even more coveted. It is difficult to distinguish a general pattern in European cuisine. One can, however, say that innards are more appreciated south of the Alps and that scepticism regarding these parts of an animal seems to be mainly a Protestant problem. One could of course handle the entire problem as the British do. They tend to overlook the fact that their 'steak and kidney pie' has anything to do with offal at all. Kidney, just like liver, is a delicacy. It's as simple as that!

In French there is the wonderful saying "manger s'apprend" - "to eat must be learned". It is not only our traditions but also our prejudices that play a part in how we judge different types of foods. Only those who are willing to question their own preconceptions can open themselves to the nuances and consistencies of new flavour experiences. In doing so, you broaden your horizon and learn to appreciate things that you always believed you didn't like.

Many offal recipes originate from a time when the wastefulness of today was inconceivable. I believe it is high time to rethink things — and that we have to learn to use all of the animal once again, which also means giving the 'internal realm' a new chance. When animals are allowed to live in dignity their meat tastes better. In times gone by,

an animal not only had a decent life, it was also respected after it was slaughtered. The farmer held every part of the body in high esteem and knew how to use it.

Unless otherwise specified, the quantities in the recipes are based on the appetite of four hungry people.

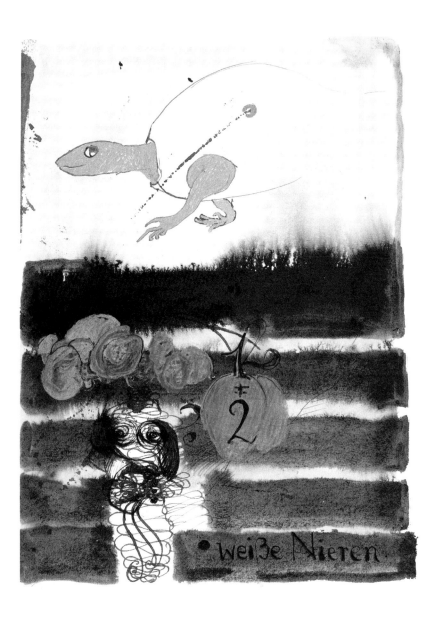

Rocky Mountain Oysters

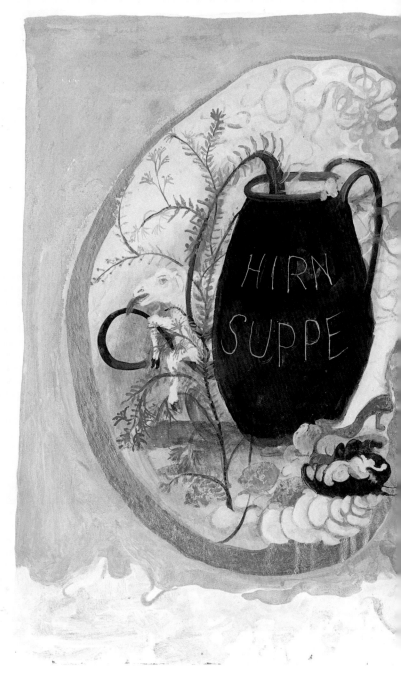

Brain Soup

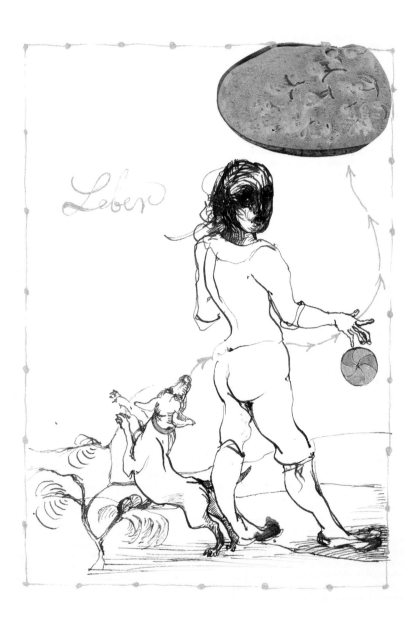

Liver

Liver

Liver is the largest edible organ. It is particularly tasty and known to be very nutritious. Calves' liver is probably the most favoured innard, a veritable delicacy. Dishes with calves' liver can often be found on the menus of good restaurants.

Beef and pork liver taste different, but wonderful in pâtés and terrines. Lambs' liver is one of the best things imaginable. Delicate and mild, and depending on where you live, possibly even very cheap – though not in France for example, where it is a delicacy and must be paid for as such. My personal favourite is chicken liver, which has a fine, buttery soft consistency. Fresh liver from well cared for animals naturally tastes best. When using deep-frozen liver it is best to let it thaw slowly in the refrigerator.

Other types of poultry and game liver are also especially delicious but unfortunately difficult to come by. Liver from old animals: best to avoid it.

One thing common to all types of liver, with the exception of pork liver, is that it should be fried gently. Liver is perfectly done when it is pink and juicy on the inside and nicely browned on the outside. It should be soft as silk in consistency. It is important that it is prepared quickly and served immediately on warm plates. The longer it is fried or has to wait for it's guests, the harder it will become. Also note that liver is only to be salted when it is finished cooking, otherwise it will become dry.

In ancient Greece and Rome, liver was considered to be a special delicacy and was the organ symbolic for courage in animals and humans alike. Even then, it was known

that force-feeding an animal increases the size of the liver. This fate not only befell geese, but also pigs, which were stuffed with figs and honey. The linguistic consequences are still apparent today: *foie* in French, *fegato* in Italian, and *higado* in Spanish are all derived from the Latin 'ficatum'. *Ficatum iecur* means fig-fattened liver.

Liver was once the highlight of any slaughter feast; particularly as in times without refrigeration it wouldn't keep long. The good old German liver sausage and the popular Swedish dishes *pölsa* and *korvkaka* have a long tradition, just like their classy cousin, *foie gras*, which attracts a very high price nowadays.

At one time, liver was mainly found on the tables of upper-class families. It was in these households that a funny kind of nonsense poetry was developed during the Renaissance. Before eating liver, a little liver doggerel would be recited, something along the lines of:

This liver is veal and not from a goat,
I'll leave it at that, let's not rock the boat.

Or:

This liver is a pig liver and not that of a piglet,
I can not find a rhyme for that, no matter how I wiggle it.

Sage liver sticks

A simple little melt in your
mouth treat!

250 g chicken liver
fresh sage leaves
butter
salt and pepper
cocktail sticks

Clean and halve the livers. Attach a sage leaf to each chicken liver half with a cocktail stick. Fry quickly in butter. Season with salt and pepper. Serve!

Apple liver sticks

250 g chicken liver
2 firm, tart apples
pickled ginger
butter
salt and pepper
cocktail sticks

Clean and halve the livers. Cut the apples into thin slices, remove the core but don't skin! Attach the apple slices and the pickled ginger to the liver with cocktail sticks. Fry quickly in butter. Season with salt and pepper. Serve immediately!

Calves' liver with calvados apples

500 g calves' liver in 1cm thick slices
100 g smoked, sliced bacon
butter
salt and pepper

For the calvados apples:
2 tart, firm apples
2 tbsp butter
3 tbsp calvados

Core the apples and cut into thick slices. Carefully fry the apples in butter. Add the calvados and cook for a few minutes. Sprinkle with salt. Keep the apples warm. Fry the bacon until crispy and then set aside. Now fry the liver over a medium heat until it is nice and brown in colour. It should still be pink inside. Season with salt and pepper but be careful: the bacon will be fairly salty. Arrange the liver, bacon and apple slices on warm plates and serve. Garnish with a little parsley! Boiled potatoes are a nice accompaniment.

Calves' liver with avocado and fresh herbs

This dish also works well
with chicken liver.

500-700 g calves' liver in 1cm thick slices
2 ripe but firm avocados
1 lemon
fresh herbs of your choice, preferably thyme and parsley
flour to coat
salt and pepper
butter

Peel the avocados and slice them lengthways. Sprinkle the juice of half a lemon over the avocados so that they stay nice and green. Toss the liver slices carefully in flour. Sauté the liver slices quickly in a pan. As soon as juice starts to come out of the meat add the avocado slices, the lemon juice and the fresh herbs with a little butter. Shake the pan gently. Serve on warm plates. Goes particularly well with jasmine rice.

Warm chicken liver salad with acacia honey and walnuts

The combination of warm and cold is particularly pleasing.
A fantastic entrée for two or appetizer for four.

500 g chicken liver
200 g mixed lettuce
100 g walnuts
acacia honey
(or another nice
runny honey)
butter
salt and pepper

Dressing:
1 garlic clove,
finely chopped
1 tbsp balsamic
vinegar
3–4 tbsp olive oil
salt

Clean and halve the livers. Roast the walnuts in a dry pan. Be careful, they burn easily! Mix the lettuce in a bowl with the dressing and then arrange on plates. Fry the liver for a few minutes on each side. Let it rest in the pan on stove for a few more minutes. Now place the liver on top of the lettuce. Sprinkle with nuts and swirl the honey on top. Serve with baguette.

Chicken liver omelette with mint

Very nice with a tomato and vinaigrette salad.
Lunch for two or an appetizer for four.

300 g chicken liver
4 eggs
fresh mint
olive oil
salt and pepper

Prepare the liver. Fry quickly in olive oil. Season with salt and pepper. Keep warm. Mix eggs in a bowl with salt and pepper. Carefully fry the omelette in olive oil. Sprinkle with mint leaves. Divide into four pieces. Serve on four plates with tomato salad. Garnish with mint leaves.

Red onion risotto with chicken liver, parsley and lemon zest

Substitute part of the broth
with white wine to taste.

500 g chicken liver
400 g Arborio or
Vialone rice
2 large red onions
2 garlic cloves
800 ml chicken stock
100 g freshly grated
Parmesan cheese
grated zest
of one lemon
olive oil
butter
salt and pepper

Prepare and halve the livers. Fry quickly in olive oil. Season with salt and pepper. Keep warm. Chop the onions and garlic and cook gently in olive oil until softened. Add the rice and stir. Add a little broth (or wine) and boil down. Keep adding the broth, a little at a time, stirring constantly with a wooden spoon. After 18 to 20 minutes the risotto should be creamy but still al dente. Carefully fold in the butter and the Parmesan cheese and stir. Let it sit in the covered pot for a few minutes before serving. Serve the risotto with the liver on warm plates. Sprinkle with Parmesan cheese, lemon zest and plenty of freshly grated pepper.

Lambs' liver with horseradish purée and fried plums

500 g lambs' liver
cut in slices
a few tbsp of flour
butter

Horseradish purée:
6 large potatoes
5 cm grated
horseradish
200 ml hot milk
2 egg yolks
50 g butter

For the plums:
10 ripe plums
2 tbsp sugar
butter
parsley
salt and pepper

Halve and pit the plums. Fry gently in butter. Sprinkle with sugar and let melt. Set aside. Boil the potatoes, let them steam off a little then mash with potato masher. Add the hot milk, egg yolk, butter and horseradish and beat until the purée is really white and fluffy. Keep warm. Toss the liver slices in flour and immediately fry them in simmering hot butter, 2 minutes on each side. Season with salt and pepper. Now serve on warm plates with the purée and the plums. Sprinkle with parsley.

Rabbit liver
with rose petals

A very easy
yet sophisticated appetizer.

500 g rabbit liver
a handful of
rose petals
butter
salt and pepper

Brown the liver in plenty of butter for 1 or 2 minutes. Season with salt and pepper. Arrange the liver on warm plates. At the last minute, sprinkle the rose petals on top. Serve!

Lambs' liver
with figs

500 g lambs' liver
cut in slices
500 g figs
(preferably
fresh figs)
2 tbsp balsamic
vinegar
100 ml veal stock
4 tbsp fig brandy
(Boukha) or
Madeira
1 tsp icing sugar
150 g butter
salt and pepper

Wash the figs, cut them in half and sprinkle with icing sugar. Fry slowly in a pan with a nut-sized piece of butter. Set aside. Fry the lambs' liver quickly on both sides in some butter. Season with salt and pepper and keep warm. For the sauce, mix the meat juices with vinegar and fig brandy or Madeira. Add icing sugar and veal stock and let simmer for a few minutes. Remove the sauce from the heat and work in the butter. Beat well with a whisk. Season with salt and pepper. Serve immediately with the figs and bulgur or couscous!

Lambs' liver a là Rydberg

500 g lambs' liver
diced in 1cm cubes
5 average sized
potatoes diced
in 1cm cubes
2 large red onions
finely chopped parsley
butter
salt and pepper

Chop the onions and fry gently in butter. Keep warm. Boil the diced potatoes for 4-5 minutes in salted water. Drain and let the potatoes steam off. Fry the diced liver. Now carefully mix the liver, potatoes and onions in the pan. Sprinkle with parsley. Season with salt and pepper. Raw egg yolk, Dijon mustard and pickled beetroot make a good accompaniment!

HEART, ANDOUILLETTE, STOMACH, BRAIN, TRIPE, SWEETBREADS,
TONGUE, SPLEEN, ANIMELLES, LIVER, KIDNEYS

Andouillette

Une bonne andouillette a le goût de la merde,
mais pas trop.
(French proverb)

Andouillette is a French sausage made from innards, with a unique scent and very proud tradition. The most famous Andouillettes are to be found in the city of Troyes in the Champagne region of France. Indeed, it is claimed that this sausage has been enjoyed here since at least 877, when Louis II was crowned king. Famous personalities such as Louis XVI and Napoleon are just a few of the prominent historical figures who went out of their way to taste this extraordinary delicacy. The sausage consists of two parts chitterlings and one part tripe, but making an authentic andouillette out of this is a true art.

The meat is cut into strips, bent, then curved and folded in a very complicated pattern. It is seasoned with onions, salt and pepper then stuffed into a pig intestine and cooked slowly for five hours in a fresh herb bouillon, for which the recipe is secretly guarded. If you order a sausage in a restaurant with the original 'AAAAA' signature (Association Amicale des Amateurs Authentiques Andouillettes, or roughly translated, The Friendly Association of Authentic Andouillette Lovers) you can be sure to receive a bona fide, good and proper Andouillette.

There are numerous recipes: poached in champagne, with foie gras, fried with mashed potatoes and mustard or baked '*au four*', as in the following recipe.

Andouillette
au four

4 Andouillettes
10 finely chopped
shallots
200 ml white wine
50 g butter
salt and pepper

Preheat the oven to 175°C. Melt half of the butter and cook the onions until softened (set aside). Make a few small slits in each Andouillette so that they don't burst in the oven. Fry the sausages until golden brown in the rest of the butter. Place the fried onions and the Andouillettes in an ovenproof dish and pour over the white wine. Bake for 20−25 minutes. Serve immediately with tasty horseradish purée (recipe on pg. 23) and peas.

Pâtés

Pâté

Taken quite literally, a pâté is always baked with a pastry crust. The word has the same origin in French, *pâté*, as in Italian, *pasta*, both meaning pastry. However, the word pâté is often also used for terrines made without a *croûte*, or pastry crust, and prepared in a form with or without a bacon casing.

Pâtés were the highlight of any medieval feast. They could be made with any number of conceivable delicacies; oysters, goose liver, tortoises, dried cod or calves' brain. Until the 16th century, pâté was the most favoured dish on the dining tables of the wealthy. It was almost impossible to imagine a dinner without a pâté — for example in the shape of a château, an eagle, a stag or a peacock. So called 'live pâtés' were also very popular: When they were cut open, the guests would be surprised by the sensational appearance of exotic birds, croaking frogs or lightly clad young beauties.

During Wilhelm the Duke of Bavaria's wedding cele-bration in 1568, an enormous pâté was brought in, out of which sprang Ferdinand of Austria's favourite dwarf. He greeted the guests dressed in a suit of armour and waving a flag. No less amazing was the fact that there were forty different warm dishes also hidden inside this pâté: just going to prove the incredible dimensions of this wedding feast. Our recipes are not quite as demanding as this. Incidentally, the fact that pâtés were so popular many centuries ago had another very simple reason: Pâtés can

be eaten and enjoyed even without teeth; a crucial factor
back then when there was neither proper dental hygiene
nor dentures.

Chicken liver mousse
with walnuts and raisins

Perfect for a buffet or as an appetizer
for 12 – 14 people.

500 g chicken liver
2 red onions,
chopped finely
100 g walnuts
200 g butter
at room temperature
and extra butter
for frying.
sultanas to taste
(soaked for
a few hours,
perhaps in port
or sauternes wine,
but lukewarm
water is also fine)

Roast the walnuts in a dry pan. (Careful, they burn very easily!) Set aside. Fry the onions until soft. Clean the liver and fry in butter very breifly. Let it cool. Purée the liver and the onions. Beat the butter with a mixer until fluffy. Chop the walnuts and the raisins then mix carefully but thoroughly with the butter and the liver mixture. Line a baking dish (or use two small ones, for finer slices) with cling film and fill with the mixture. Refrigerate overnight so that the nuances of the different flavours can 'marry'. Serve with lettuce or sautéed pears.

Calves' liver terrine with pistachios and thyme

*1 kg calves'
liver
250 g soft
butter
4 tbsp cognac
1 red onion
50 g pistachios
125 ml
whipping cream
a small bunch
of thyme
salt and pepper*

Clean the liver and chop into small pieces. Gently fry 400 grams of the liver in 50 grams of butter. Take the liver out of the pan, (don't throw away the frying juices!) place in a bowl and drizzle with cognac. Set aside. Chop the onion finely and fry with the remaining liver for 3 – 5 minutes. Let it cool. Now purée the liver, frying juices and cognac (from the liver) together. Press the purée through a fine sieve. Roughly chop the soaked liver and the pistachios. Mix the liver purée with the cream and the rest of the soft butter and whip until creamy. Chop thyme finely. Season the forcemeat with thyme, salt and pepper. Fold the liver cubes and pistachios into the forcemeat mixture. Line one large or two small casserole forms with cling film and spread the forcemeat inside. Cover and place in the refrigerator overnight. Cut into slices and serve, for example with the calvados apples (on pg. 18) and toast.

Crostini

Crostini literally means 'little toast', but that doesn't mean that they are always toasted. They can also be fried or served 'au naturel'. Some dip crostini in broth, others in vino santo; they can be served cold, lukewarm or hot from the oven.

In the past, crostini were a simple lunch for farmers and field labourers rather than an appetizer: slices of bread with garlic spread on it, a few slices of tomato on top, seasoned with salt, pepper and olive oil. In medieval and Renaissance times, the tables at opulent banquets were not set with plates - instead the food was served on a large tablet. One would use a slice of bread to easily and elegantly get the food into one's mouth. (It mustn't be forgotten that forks were only first used during the late Renaissance in the stately homes of Italy.) These dainty treats were certainly relatives of our present-day crostini.

Today we find crostini everywhere and in numerous varieties, but the Queen of Crostini will forever be the Tuscany classic — the *crostini di fegatini*.

Crostini
di Fegatino

This recipe is very simple
and can be easily varied; some cooks like to use
spleen instead of liver - also very delicious!

200 g chicken liver
30 g butter
1 tbsp red wine vinegar
1 tbsp small capers
1 tbsp finely
chopped parsley
8 finely chopped
sage leaves
salt and pepper

The crostini:
Good quality white
bread, day-old is good,
cut into small slices.
olive oil
1 garlic clove

Preheat the oven to 200°C. Clean the liver and divide it into four pieces. Fry the liver with the sage very gently in butter. Add vinegar, capers and parsley and fry briefly at a high heat. It is important to do this quickly so that the liver stays pink and creamy inside! Place the bread slices on a baking tray. Drizzle with olive oil and toast them golden brown. Now chop the liver mixture and spread the forcemeat onto the crostini. Serve with Chianti classico!

Crostini with lamb sweetbreads

800 g lamb
sweetbreads
100 g fresh herbs to taste
(I like to use coriander,
parsley and chives)
a dash of lemon juice
a good shot of
mild olive oil
salt and pepper

The crostini:
good quality white bread
3 garlic cloves
olive oil

Rince the lamb sweetbreads and remove the fat and skin. Put them in cold water with lemon juice and bring slowly to the boil, remove them immediately and dry them. Chop the meat very finely and mix well with the finely chopped herbs, olive oil, salt and pepper. Toast the bread slices and rub them with garlic. Drizzle olive oil on top and cover with the lamb-sweetbread mixture. Serve immediately!

Sweetbreads

In his legendary book, *The Science and Art of Cooking* (1885), the Swedish cookbook author C. E. Hagdahl writes: "Veal sweetbreads are the most costly part of all ruminant animals used for human consumption and are far more expensive than their nutritious value or even their flavour justify. Though, as they are a fashionable dish, the consumer will generally accept the rising price."

Hagdahl can say what he likes, but veal sweetbreads are a fantastic delicacy, possibly the most delicious part of any animal and in any case the most expensive. Lamb sweetbreads are also a wonderful delicacy, very affordable and a little easier to prepare than veal sweetbreads. Sweetbread, also known as the thymus gland, is found in the ribcage of an animal and is responsible for growth. It disappears as soon as an animal is fully grown. Veal sweetbreads have been enjoyed since times immemorial, but only became really popular in the 16th century. Because they taste good, but maybe also because of their high price, they were particularly a favourite on the tables of affluent families. Up until the 1950s one could hardly find a self-respecting restaurant that didn't offer sweetbreads, preferably as ragout fin in puff pastry as an appetizer!

Sweetbreads can be prepared in various ways: boiled, steamed, sliced and fried, grilled or baked. Be careful while cooking though: If they are cooked for too long, they become dry and floury. As with many other types of offal, sweetbreads should be juicy and pink in the middle!

Sweetbread has a fine and subtle flavour and lends itself very well to combinations with various other ingredients. There is almost no limit to the endless possibilities for those who dare to rediscover this nearly-forgotten gem. Unfortunately, sweetbreads are now usually only found in truly exclusive restaurants.

Sweetbreads can be bought from the butcher ready to cook. If however, you can wait a few hours, sweetbreads should be soaked in cold water first. This makes them even more enjoyable!

Veal sweetbreads à la Florentine

300 g veal sweetbreads
breadcrumbs
1 lemon
butter
parsley
salt and pepper

Blanch the sweetbreads. Cool in cold water. Remove the skin and sinews. Cut into slices. Combine the breadcrumbs, salt and pepper and toss the slices in the coating. Now carefully fry in butter until golden brown, approx. 3 minutes on each side. Serve immediately on warm plates with parsley and lemon.

Lambs' sweetbreads with chanterelles and bacon

500 g lambs'
sweetbreads,
about 3 per person
500 g chanterelles
or other mushrooms
300 g smoked,
sliced bacon
200 g mixed
lettuce
100 g walnuts
fresh thyme
butter
salt and pepper

Prepare the sweetbreads as usual. Clean the mushrooms (if possible, don't wash them!) and fry in butter. Set aside. Prepare the lettuce and arrange on plates. Carefully fry the sweetbreads in butter. Now drape the sweetbreads over the lettuce (keep the frying juices in the pan) and lay the mushrooms on the sweetbreads. Decorate with the bacon rashers and the walnuts and sprinkle with thyme. Pour over the butter and serve immediately.

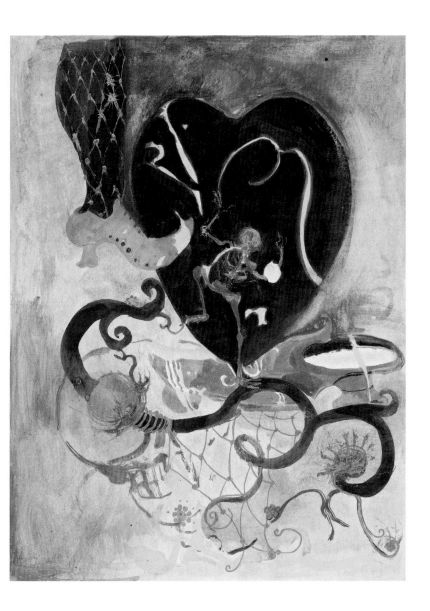

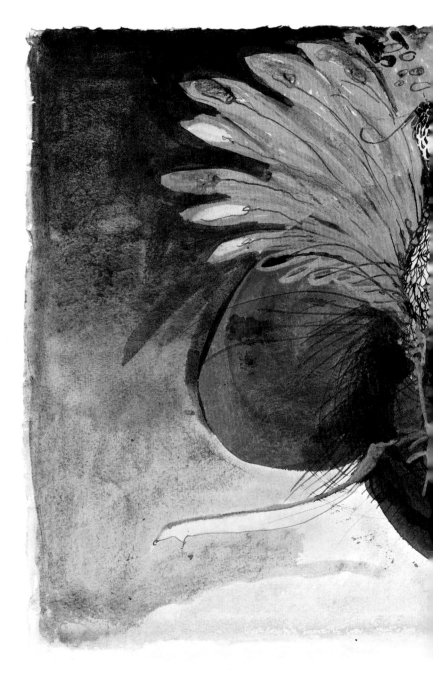

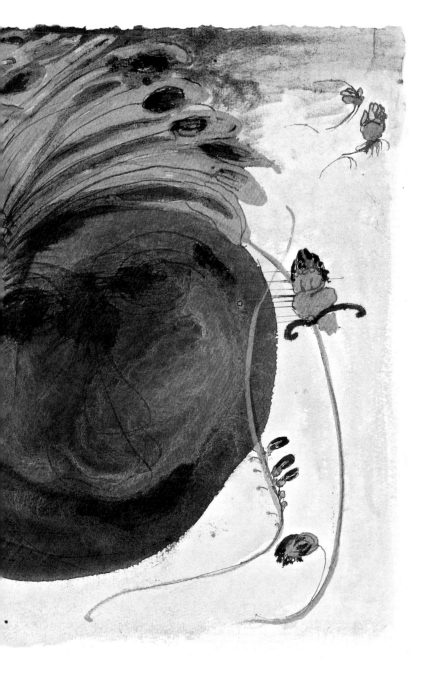

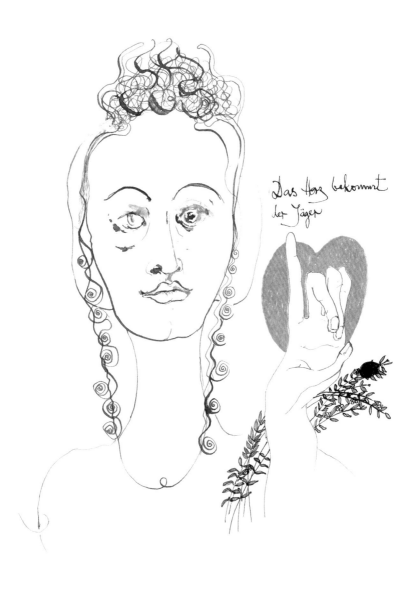

Das Herz bekommt
der Jäger

The hunter gets the heart

Heart

He woke her and let her shyly eat of the
small and utterly glowing heart.
(Dante, Vita Nova)

This very active muscle may not be the most refined of the internal organs, nevertheless, it has a hearty, robust quality and is also very affordable and very, very nutritious. Heart has a tender and firm, lean meat consistency and of all the types of offal, it is the one most similar to 'normal meat'. Heart tastes best when the inside is done fairly rare to pink. If it is cooked longer than this, it can be as tough and dry as an old boot: Be careful!

The hearts of various animals don't differ greatly from one another. I find lamb hearts the most agreeable; they are not as huge as a beef heart and not as expensive as veal heart.

In a hunting group, the heart of the hunted animal is given to the hunter who kills it. It is a privilege to receive and enjoy this muscle steeped in symbolism. Try it, just take heart and don't be afraid! You can stuff, cook, roast and even grill a heart. A marinade makes the meat tender and delicious, as you'll find with the following recipe.

Marinated lamb heart on a bed of lettuce with nectarine salsa

A nice appetizer for four or
a main course for two.
Serve with good quality bread!

3 lamb hearts
200 g mixed
lettuce

For the marinade:
olive oil
a shot of
balsamic vinegar
finely chopped
thyme
butter for frying
salt and pepper

Halve the hearts and wash. Remove the inner strands and pat the hearts dry. Cut the halves in slices as thin as possible. Mix the meat with vinegar, finely chopped thyme, salt and pepper and marinate in refrigerator for at least 12 hours. Prepare the lettuce and divide onto plates. Pour a little high-quality olive oil over the lettuce. Now fry the meat in hot butter for about 5 minutes. Lay the meat on the lettuce and serve with:

Nectarine salsa

4 nectarines
1 red onion, chopped
zest and juice
of one lemon
finely chopped
parsley
a pinch of sugar
2 tbsp olive oil
salt and pepper

Mix lemon juice and zest together with olive oil, salt, pepper and sugar. Cut the nectarines into small chunks and mix with the onion and parsley. Let it sit for a few hours so the flavours can blend.

Tongue

"Die Zünglein der Nachtiga[l]
die Herzen für die Gich[t]"

"For kings and princes, nothing less than the tongues of nightingales for pure enjoyment and the hearts to cure them of gout."

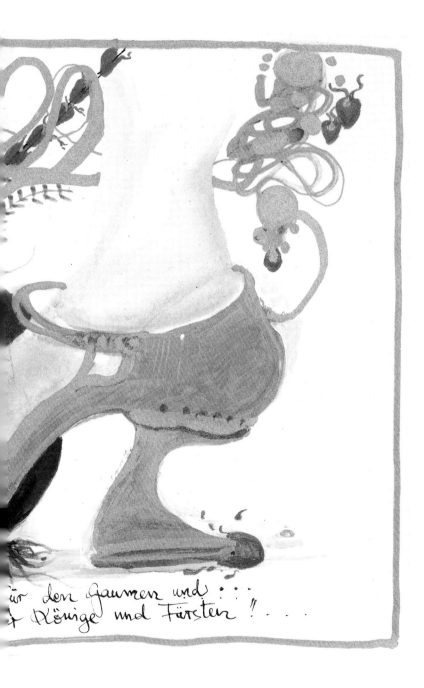

ür den Gaumen und ...
+ Könige und Fürsten !"...

Tongue

Tongue – of various animals and in varying sizes, from whale to nightingale – has been very popular since ancient times. To guarantee the pure enjoyment of veal tongue, various methods were developed to cleanse the animal prior to slaughter.

Descriptions of this can be found in old housekeeping books. For example, it is suggested that the animal's tongue be regularly rubbed with salt und bathed in wine. This educes a healthy thirst and this increased hydration enormously improves the quality of the meat. Once the animal's time has come, the tongue is ready to become a veritable choice morsel.

Boiled beef or lamb tongue is a great delicacy that can be tastily prepared in many ways. It takes a long time to cook a beef tongue but one hardly needs to do a thing. It cooks away all by itself and is ready when a needle can be easily pushed through the tip.

In the late Middle Ages whale tongue was extremely 'en vogue' and also during the Renaissance, Catherine de' Medici was said to have been very enthused by this enormous treat.

Bird's tongues were a widespread delicacy in ancient Rome. The gourmet Apicius claimed that flamingo tongues had an especially subtle taste, whereas Caligula found nightingale tongues to be the best. For him it was as if the heavenly birdsong had been transformed into this edible delicacy.

Boiled and cured ox tongue with purée of swede

This Swedish classic is usually served
with various kinds of mustard

*1 cured ox tongue
(1 to 1.5 kg)
1 large onion,
spiked with 6 cloves
5 allspice corns
5 white peppercorns
2 bay leaves
parsley
salt (check first to see
if the tongue has already
been sufficiently salted!)*

*Puree:
500 g swede, chopped
into small pieces
2 large carrots,
thickly sliced
6 potatoes cut into chunks
200 ml tongue stock
salt and pepper
butter to taste
parsley*

Rinse the tongue under cold water. Cover with water and bring to the boil. Simmer for a few minutes. Drain water and bring the tongue to the boil once again in fresh, cold water. Add the remaining ingredients and steam on a low heat for 2-3 hours. Remove the skin while the tongue is still warm. (The colder the tongue is, the harder it is to skin it.) Cook the root vegetables for approx. 20 minutes in salted water. Drain. Mash the root vegetables with a potato masher. Add stock. Season to taste with salt, pepper and butter. Cut the tongue in thin slices and serve with the puree. Sprinkle with parsley.

Lambs' tongues on a bed of lettuce with horseradish, apples and coriander

8 lambs' tongues
(approx. 700 g)
zest of half a lemon
6 cloves
2 cinnamon sticks

Salad:
200 g mixed
lettuce leaves
3 firm, tart apples
1 small piece of
horseradish
fresh coriander

Dressing:
1 tbsp Dijon mustard
1 tbsp vinegar
3 tbsp olive oil
salt and pepper

Soak the tongues for a few hours in cold water. Cover with cold water and bring to the boil. Drain. Simmer the tongues for approx. 40 minutes on a low heat together with the lemon zest, the cloves, the cinnamon sticks and a little salt. Arrange the lettuce and the apple slices on the plates. Now prepare the dressing (it should be as creamy as possible, so stir vigorously as you would when preparing mayonnaise). Grate the horseradish and chop the coriander. Drain the tongues and peel the skins off while they are still warm. Cut them into fine slices and arrange them on the plates. Add dressing. Sprinkle with horseradish and coriander. Bon appétit!

Leber

Herz

Niere

liver, heart, kidneys

Kidney 'un bon petit crétain'

Kidneys

Kidneys

*Indeed, what could be more touching
and delightful than a lovely kidney, opened like a heart
and ready to soak up an amber-coloured scoop
of Isigny butter, melting in it like a sweet dream.*

(Fulbert-Demonteil)

Alexandre Dumas writes that the distinguishing taste of kidneys is slightly urinary and that this is precisely what kidney connoisseurs especially appreciate. That may be the case, but let's not go into that in any more detail here. Whether it is true or not, one thing is certain: Kidneys can be much more than steak and kidney pie.

Kidneys were mentioned many times in the Old Testament. They are seen metaphorically, often together with the heart, as the centre of emotions and innermost thoughts. In the original text it is the kidneys that rejoice rather than the heart!

In the Middle Ages it was believed that one's libido had a direct connection with the kidneys. Whoever was unfaithful, and additionally unlucky, may have ended up having a kidney cut out as punishment for their adultery. It is not clear whether consuming kidneys raised the risk of infidelity.

Veal kidneys are mild and very subtle in flavour. Before preparation, they must be soaked, de-skinned and patted dry with paper towel. They can be fried whole or

in slices but one should not remove the little bit of fat in the centre.

Lamb kidneys are also a great delicacy and furthermore, very easy on the wallet. Pork kidneys are something of a southern Italian speciality. They have a fairly strong flavour which is not for everyone, though I find that most will like a cleaned pork kidney if it has undergone a lengthy milk bath. Otherwise, you can rub pork kidneys with coarse salt and let them draw for a few hours.

Of particular importance: When serving kidneys, the guests must wait for the meal and not the other way around. Kidneys must be served immediately and mustn't be left to wait, otherwise they will turn hard.

Lamb kidneys
with mint

600 g lamb kidneys
2 tsp calvados
2 tbsp white wine
200 ml cream
100 ml lamb stock
1 bunch of fresh mint
juice and grated zest
of half a lemon
butter and oil
salt and pepper

Clean, soak and dry the kidneys. Sauté in oil and butter until they are pink inside then keep warm. Douse the gravy with calvados and white wine. Stir in cream and stock and let it simmer and thicken a little. Finely chop the mint. Season sauce with lemon juice and zest, salt and pepper. Add mint and a little more butter. Pour the sauce over the kidneys and serve with puréed celeriac and green salad.

Pork kidneys
with gremolata

Gremolata is an Italian spice blend
that is often served with Osso Buco but is also
delicious with pork kidneys!

4 pork kidneys
butter and oil
salt and pepper

Gremolata:
1 untreated lemon
3 garlic cloves
a bunch of parsley
a little bit of
coarse sea salt

Clean and soak the kidneys. Lay kidneys in cold milk for 2 hours. Dry, halve and cut in slices. Grate the lemon. Finely chop garlic and parsley. Salt carefully. Mix well. Sauté the kidney slices in butter and oil for a few minutes, turning constantly. Season with salt and pepper. Sprinkle the gremolata over the liver slices and serve with polenta and a green salad.

Kidneys
in sherry sauce

500 g lamb kidneys
1 red onion,
sliced thinly
1 garlic clove
100 ml dry sherry
1 tbsp chopped
parsley
olive oil
salt and pepper

Wash, soak and dry the kidneys. Cut into quarters. Finely chop the garlic and thinly slice the onions. Heat oil in a pan and sauté the kidneys, turning often. Remove from heat and drain the juices. Keep kidneys warm. Soften the onion and garlic in oil. Add kidneys and sherry. Simmer until the kidneys are done. Season with salt and pepper. Garnish with parsley. Serve immediately!

Veal kidneys with mushrooms and chervil

500 g veal kidneys
200 g mushrooms
(preferably
chanterelles)
1 small red onion
2 garlic cloves
100 ml cream
a dash of white wine
chervil
butter
salt and pepper

Clean, soak, dry and cut the kidneys into thin slices. Gently soften the onion and garlic in butter. Add mushrooms and steam. Now quickly fry the kidney slices in hot butter. Season with salt and pepper. Blend cream and wine into the mushroom and onion mixture. Let it reduce for a few minutes and season with salt and pepper. Add the kidneys. Sprinkle generously with chervil. Serve directly out of the pan, preferably with potato purée and slightly sweet glacéed carrots.

Lamb kidneys
with sautéed pears

8 lamb kidneys
4 ripe pears
2 tbsp brown sugar
fresh thyme
butter
salt and pepper

Halve the pears and remove the cores. Fry gently in butter, sprinkle with sugar and let melt. Keep warm. Clean, soak and then dry the kidneys. Halve and cut into thin slices. Sauté the kidneys quickly in butter (they should be slightly pink inside). Add the pears. Season with salt and pepper and sprinkle with thyme. Serve with bulgur or couscous.

Devilled kidneys

8 lamb kidneys
2 tbsp mango chutney
1 tbsp Dijon mustard
1 tsp Coleman's
Dry English Mustard
Powder
2 tbsp lemon juice
4 slices of white bread
butter
cayenne pepper
salt

Clean, soak and dry the kidneys. Halve the kidneys without slicing them completely through. For the marinade, combine the chutney with both mustards, lemon juice and cayenne pepper in a bowl. Add the kidneys and marinate for one hour. Brown the kidneys quickly in butter. Keep warm. Toast the bread. Spread butter and approx. half a teaspoon of marinade on each slice of toast. Lay a pair of kidneys on each slice and serve immediately (with beer!).

Robbie's rosemary-skewered lamb kidneys

8 lamb kidneys
15 rosemary twigs
butter
salt and pepper
lemon wedges

Clean, soak and dry the kidneys. Halve. Remove enough of the rosemary needles so as to make a skewer. Now thread half a kidney onto each skewer. Fry in butter, approx. 3 minutes each side. Season well with salt and pepper. Serve with bulgur, roast vegetables and lemon wedges.

Hirn

Joseph Fröhlich – Hofnarr · 1736 · von August dem Starken

Brain
Joseph Fröhlich –1736 – court jester of King August the Strong

Brain

Many people innocently believe that they have never eaten brain. They are wrong. One often eats brain, but in an unrecognizable form, hidden in sausages and pâtés.

Brain is one of those parts of an animal that used to be a delicacy and is now thought to be virtually inedible. This is an unfortunate waste, as brain is one of the finest and tastiest of all of the organs.

Lamb brains are significantly cheaper than their big brother, the more well-known veal brain, but just as delicious: Sweet and small and very similar to a large walnut.

Butchers generally offer brain ready-to-cook. Nonetheless, you should soak it for an hour in cold water or water with lemon juice prior to preparation. Afterwards, carefully peel away the skin and rinse it in fresh cold water until it has turned snow white.

Lamb brains with beurre noir

4 lamb brains
1 carrot
2 leeks
2 stalks of celery
1 bunch of
fresh herbs
(e.g. parsley root,
thyme and 1 bay leaf)
10 pepper corns
150 g butter
finely chopped
parsley
1 shot of white
wine vinegar
salt and pepper

Soak the brains for a few hours in cold water with a tablespoon of salt. Simmer vegetables and herbs for an hour then drain through a kitchen sieve. Reheat liquid. Lay the brains in the simmering broth and gently simmer for 8 minutes. Remove and pat dry. Cut into 1cm thick slices and lay on a warm plate. Season with salt and pepper and sprinkle with parsley. Heat the butter in a pan, until brown, and then drizzle it over the brains. Finally, pour a shot of vinegar into the hot pan, swirl briefly and pour over the delicacy!

Lamb brains, roasted red bell pepper and coriander salad

2 lamb brains
1 carrot
2 leeks
2 celery stalks
a bunch of fresh herbs
10 pepper corns
4 red bell peppers
fresh chopped
coriander
small black olives
(with stones!)
olive oil

For the dressing:
juice of half a lemon
olive oil
salt and pepper

Prepare broth and simmer brains as above. Let brains cool in broth. Halve the bell peppers and grill on a high heat until black 'blisters' form. Plunge in cold water and remove the skins. Cut the bell peppers in strips and arrange on a plate. Cut the cooled brains into slices and arrange on top of the bell peppers. Pour on dressing and garnish with coriander and olives. Serve immediately with bread.

Tripe

It is a great shame that for many people, to think of tripe is to think of dog food. Tripe has always been very important as a poor man's meal.

In gastronomically distinguished countries such as China, France, Italy and Turkey, tripe has always had special status as good traditional fare, 'street food', but also as the ultimate delicacy.

The tripe recipes found in old cookbooks are very time consuming. Here the cleaning of tripe using various complicated methods is described in great detail. In some places today, however, one can buy cleaned, pre-cooked and even pre-cut tripe from the butcher: Very practical.

The four stomachs are different in consistency and structure. In 'Les Tripes à la mode de Caen', one of the most well known French tripe dishes, all four stomachs, namely blanket, honeycomb, leaf, and reed tripe, come into their own. They are boiled together with vegetables, calves' feet and cider, and then polished off at the very end of cooking with a shot of calvados. The unique aroma of tripe and the fact that they look like an old terry towel might account for the fact that they have never attained the popularity that they actually deserve. One glorious exception however is the Florentine tripe dish 'Trippa alla fiorentina', a national dish that has been enjoyed for centuries.

Trippa
alla Fiorentina

500 g precooked
tripe
1 red onion
1 carrot
¼ of a celeriac
1 large peeled tomato
1 garlic clove
2 bay leaves
500 ml meat broth
dash of dry white wine
50 g butter
plenty of
Parmesan cheese
olive oil
salt and pepper

Finely chop the onion, carrot, celeriac and garlic and fry in olive oil. Add the peeled and finely chopped tomato and the bay leaf. Simmer for a few minutes. Cut the tripe into 3 cm long, thin strips. Add to vegetables and mix well. Cover the tripe with meat broth and wine and simmer gently for approx. 50 minutes. Blend with butter and Parmesan and serve immediately!

Tripe with olives and coriander

In Turkey it's common knowledge that the
Prophet Mohammed crowned tripe as the King of Meals.
This simple dish is the proof!

500 g chopped,
precooked tripe
2 red onions
4 garlic cloves
4 good, skinned
tomatoes
4 tbsp tomato puree
1 handful
of black olives
(with stones!)
a bunch of coriander
500 ml stock
cumin
olive oil
sugar
salt and pepper

Soften the tripe with finely chopped
onions, garlic cloves and cumin in
olive oil. Add the chopped tomatoes,
tomato purée and a pinch of sugar.
Stir well. Now add the stock (the tripe
should be just covered with liquid)
and simmer for approx. 40 minutes
or until they are done. (You may have
to add a little stock.) Drizzle olive oil
on top and sprinkle with chopped
coriander and olives. Serve hot with
good bread!

Tripe with scrambled eggs

A nice simple lunch for four.

500 g cooked tripe
4 eggs
dash of
whipping cream
fresh herbs
salt and pepper

Cut the tripe into fine strips and sauté in butter. Blend the eggs with the cream and pour over the tripe. Season and sprinkle with fresh herbs. Serve immediately with green salad and good bread!

2009 ©
Charlotte Birnbaum, Christa Näher
and Verlag der Buchhandlung
Walther König, Cologne

Concept by
Charlotte Birnbaum
Illustrated by
Christa Näher
Translated by
Erika Banks, Frankfurt/Main
Designed by
Harald Pridgar, Frankfurt/Main
Produced by
Plitt Printmanagement, Oberhausen

Published by
Verlag der Buchhandlung
Walther König, Cologne
Ehrenstr. 4, 50672 Cologne
Tel.+49 (0)221/20596-53
Fax +49 (0)221/20596-60
verlag@buchhandlung-walther-koenig.de

Bibliographic information published by the Deutsche Nationalbibliothek
The Deutsche Nationalbibliothek lists this publication in the
Deutsche Nationalbibliografie; detailed bibliographic data are available at
http://dnb.d-nb.de.

Printed in Germany

Distribution UK & Eire by
Cornerhouse Publications
70 Oxford Street
GB-Manchester MI 5NH
Tel.+44 (0) 161 200 15 03
Fax +44 (0) 161 200 15 04
publications@cornerhouse.org

Distribution outside Europe by
D.A.P. / Distributed Art Publishers, Inc.
155 6th Avenue, 2nd Floor
New York, NY 10013
Tel.+1 212-627-1999
Fax +1 212-627-9484
www.artbook.com

ISBN 978-3-86560-624-2